The Drawing Center
November 3 – December 9, 2012
Main Gallery

Eli and Edythe Broad Art Museum
at Michigan State University
February 22 – May 26, 2013

MCA Denver
June 21 – September 15, 2013

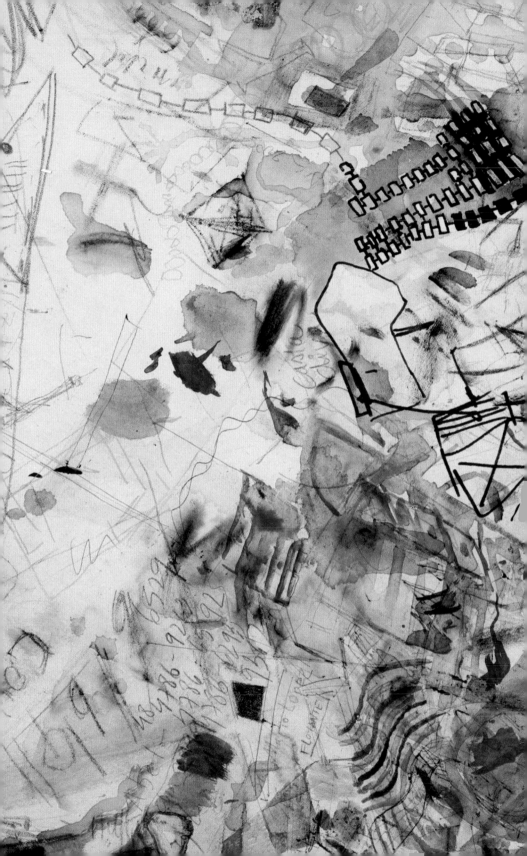

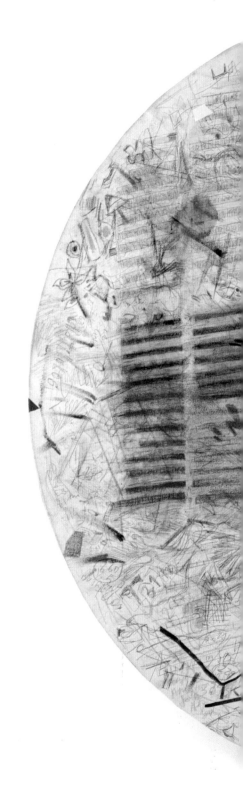

PL. 6
17 August – 3 December 2007

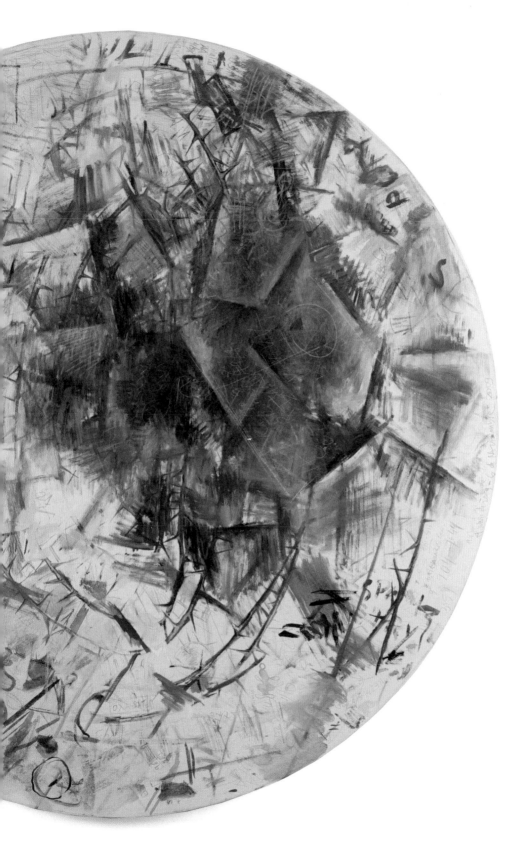

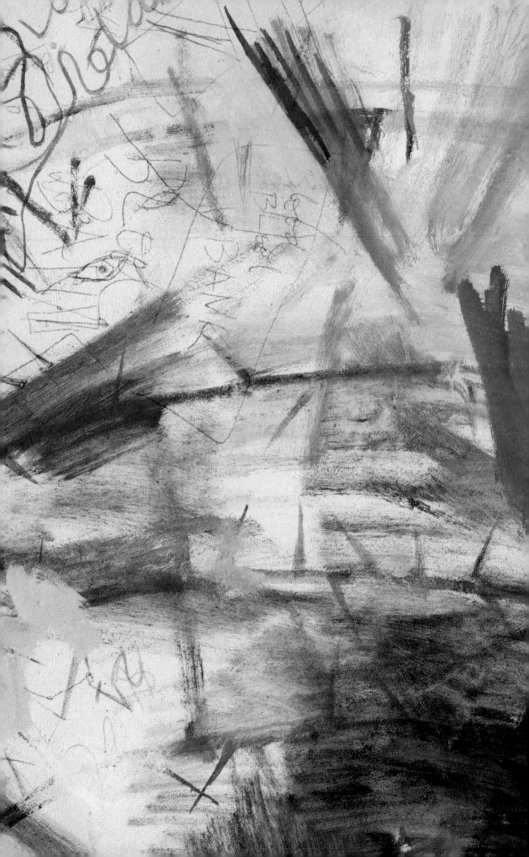

Editorial Note

Guillermo Kuitca: Diarios marks the 100th edition of The Drawing Center's *Drawing Papers* series, which began in 1999 and remains one of the most thoroughgoing conversations on the theory and practice of drawing to be found anywhere. It is only fitting then that this century mark of sorts coincides with the reopening of The Drawing Center after the renovation and expansion of its 35 Wooster Street address. With rejuvenated facilities to match its always vibrant program, The Drawing Center and the *Drawing Papers* look forward to continuing and expanding—even renovating and challenging—that conversation, for another 100 editions and beyond.

Brett Littman Jonathan T. D. Neil
Executive Director *Executive Editor*

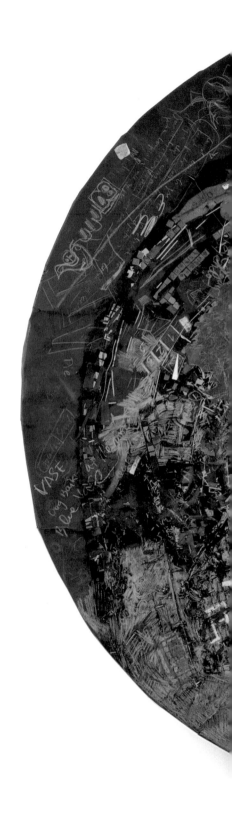

PL. 1
25 May – 20 October 2005

Guillermo Kuitca
Diarios

Curated by
Brett Littman

DRAWING PAPERS 100

Introduction by Brett Littman
Essay by Daniel Kehlmann

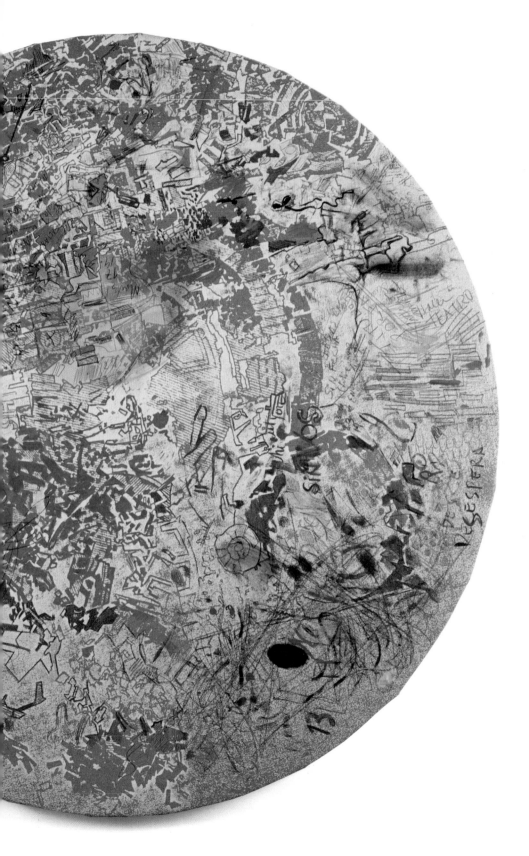

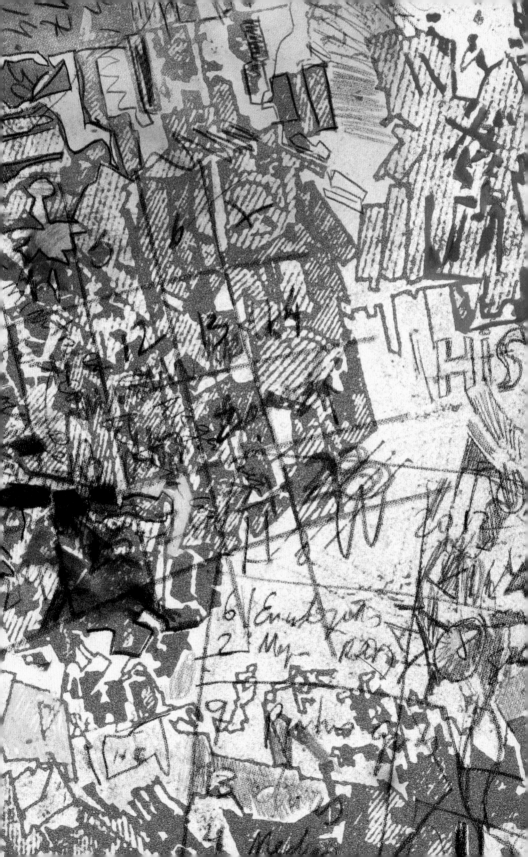

Introduction

In the middle of Guillermo Kuitca's studio in Belgrano, Buenos Aires, sits a garden table that the artist's parents had discarded. Since 1994, Kuitca has taken half-painted canvases, stretched them over this tabletop, and then, for periods ranging from about three to six months, has doodled, drawn, and recorded notes or other marginalia on its surface. Numbering now more than 40 tabletops, the series began as an act of recycling and an attempt to resolve Kuitca's discomfort with discarding a work completely. Rather than being regulated by a prescribed timeframe or recording a specific event, each of the *Diarios* responds to a personal season: phone numbers, titles of paintings, email addresses, lists, blank spots where books sat – all are part of the ebb and flow of life inside and outside the studio.

The *Diarios* are an independent body of work that allows Kuitca to return painting, which is often more reified and final, to the more fluid and inchoate condition of drawing and writing. Although the canvases contain remnants of previous ideas and compositions, the resulting works depict something separate from the issues that drive his oeuvre. The table acts to record all of the activity in the studio, and the final work becomes a hybrid of intentionality and chance. These are narrative paintings without plots and abstractions without composition.

This is the first exhibition of the Diarios in the US. Other groupings from this body of work were shown at the Cartier Foundation in Paris and at the 2007 Venice Biennale (curated by Robert Storr), where Kuitca had also been selected to represent Argentina in its national pavilion.

For The Drawing Center, these works are interesting for two primary reasons (though of course there are more). The first is that they exist outside the category of traditional drawing and challenge us, because their substrate is canvas, to think beyond the prescriptions of our medium. As loose renderings made up of pencil jottings, half-sketched ideas, and handwritten names, they subvert our understanding of what drawing is. The second is that, when taken together with its complementary exhibition of Colombian artist José Antonio Suárez Londoño's *Yearbooks* in our Drawing Room gallery, this show represents the beginning of a multi-year institutional curatorial exploration of Latin American drawing. The Drawing Center's Curator Claire Gilman and I have been traveling in Latin America over the past several years, and we have been very excited by our studio, gallery, and museum visits. It is our opinion that the artists working in this part of the world offer new perspectives on the issues and concerns related to contemporary drawing, and we are planning a series of exhibitions with other artists from Peru, Colombia, Brazil, and Argentina in the next three years.

There are many people who have been involved in making this exhibition a reality, but first and foremost I would like to thank Guillermo Kuitca for his generosity of spirit in collaborating with me and The Drawing Center on this exhibition. Since my first visit to his studio in Buenos Aires in 2008, we have had many rich conversations about his work, the art world, and life in general – and for that I am very grateful.

I would also like to thank Angela Westwater at Sperone Westwater Gallery for all of her advice and support. Maryse Brand, who works with Guillermo at Sperone Westwater Gallery, also deserves special recognition for all of the effort, energy, and enthusiasm she has put towards this project.

I am very proud that we were able to have the world-renowned novelist Daniel Kehlmann participate in this catalog. His evocative essay, "Of Cities, Maps, and Lines," which seamlessly moves between fact and fiction, is a perfect distillation of Kuitca's aesthetic impulses.

From The Drawing Center, I want to thank my fantastic staff: Anna Martin, Registrar; Nova Benway, Curatorial Assistant; Nicole Goldberg, Development Director; Peter and Joanna Ahlberg at AHL&CO; and Jonathan T.D. Neil, Executive Editor, for helping make this exhibition and catalog possible.

We have had very generous support for *Guillermo Kuitca: Diarios* and the accompanying publication from Bettina and Donald Bryant, Jr., Charles Van Campenhout and Risteard Keating, Solita and Steven Mishaan, Cindy and Howard Rachofsky, and an anonymous donor. I am also honored to announce The Mario Gradowczyk Public Program Series, in memory of Mario Gradowczyk, which is funded by Felisa Gradowczyk, Diego Gradowczyk, and Isabella Hutchinson. Their gift will support all public programming related to the institution's upcoming Latin American exhibitions. Mario was instrumental in organizing my first trip to Buenos Aires, and he introduced me to many wonderful artists in Argentina, including Guillermo. He was a wonderful, generous, and intelligent man, and I am very saddened he is not here with us to celebrate this exhibition.

Lastly I want to thank my colleagues Michael Rush, Director of the Eli and Edythe Broad Art Museum at Michigan State University, and Adam J. Lerner, PhD, Director & Chief Animator of the MCA Denver, for agreeing to host this important exhibition at their respective venues.

Brett Littman
Executive Director

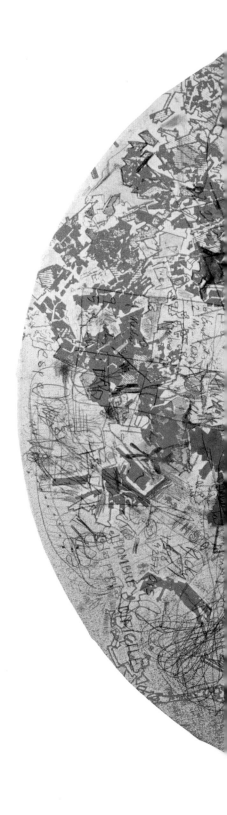

PL. 2
20 October 2005 – 14 March 2006

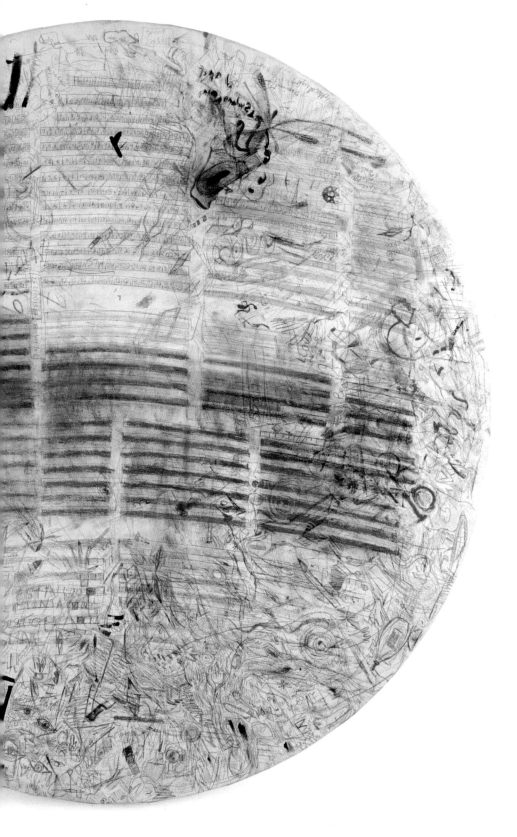

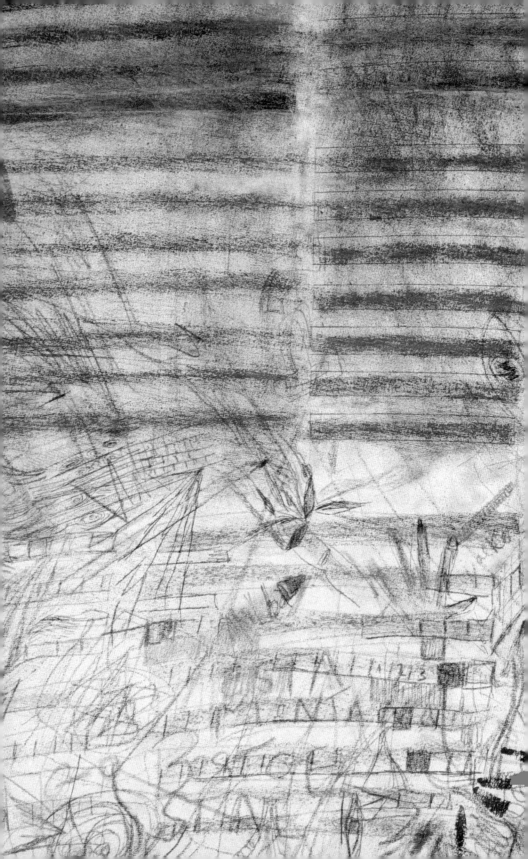

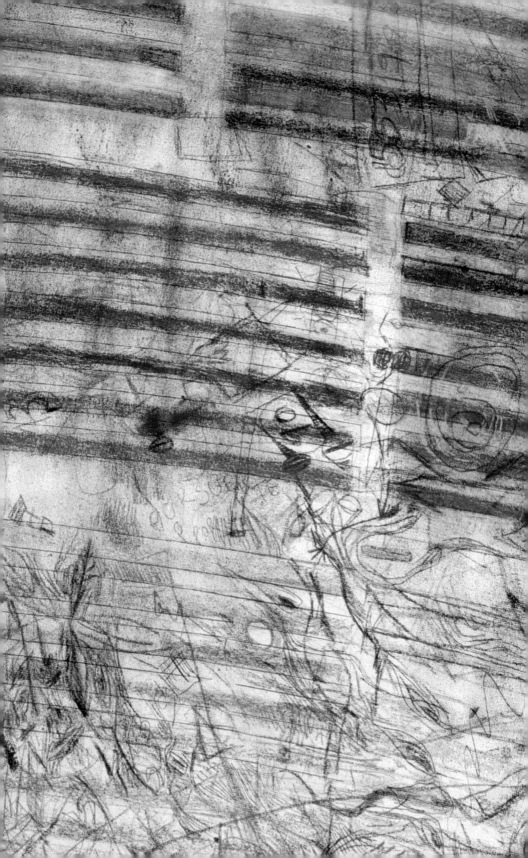

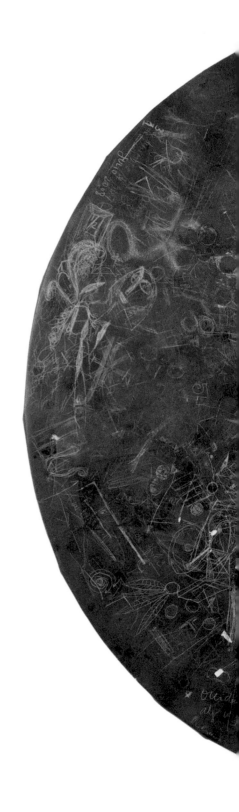

PL. 7
3 December 2007 – 1 July 2008

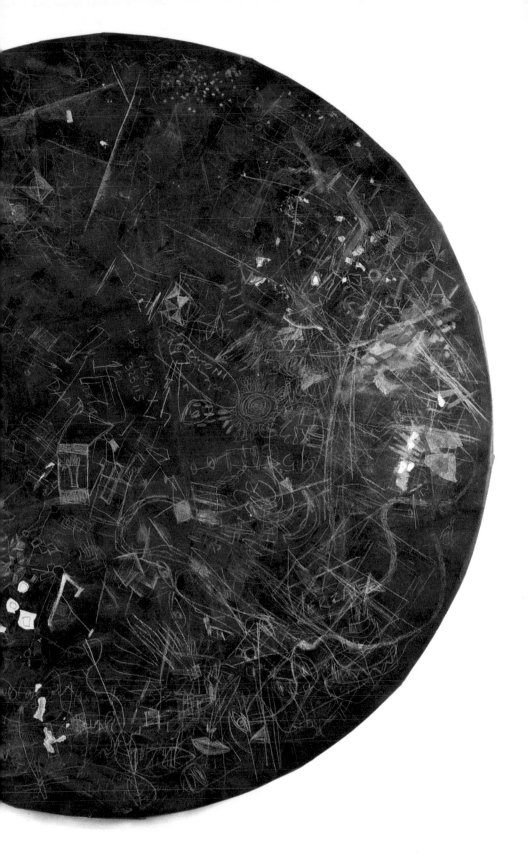

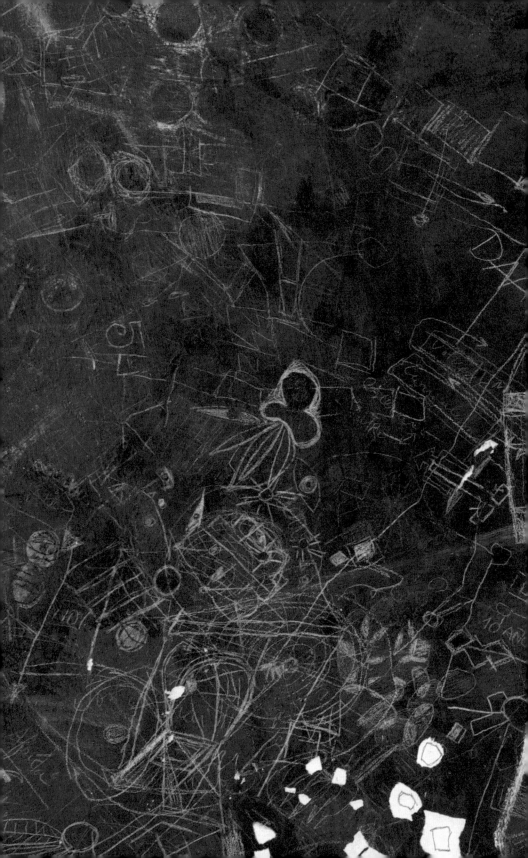

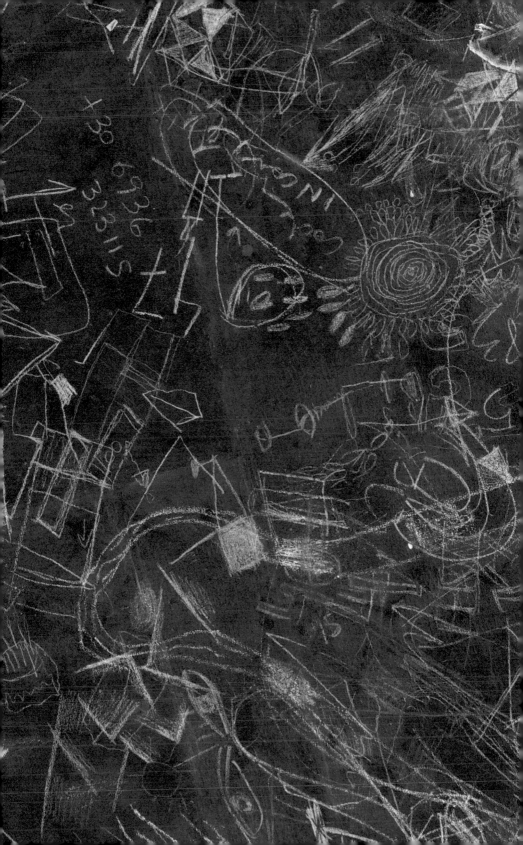

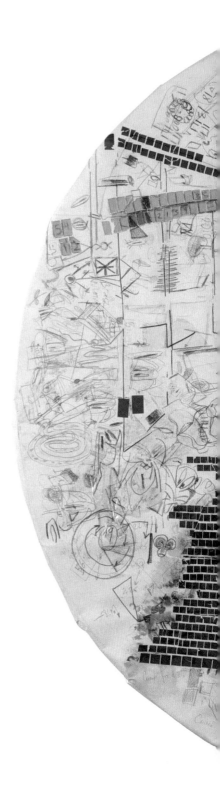

PL. 8
1 July – 16 October 2008

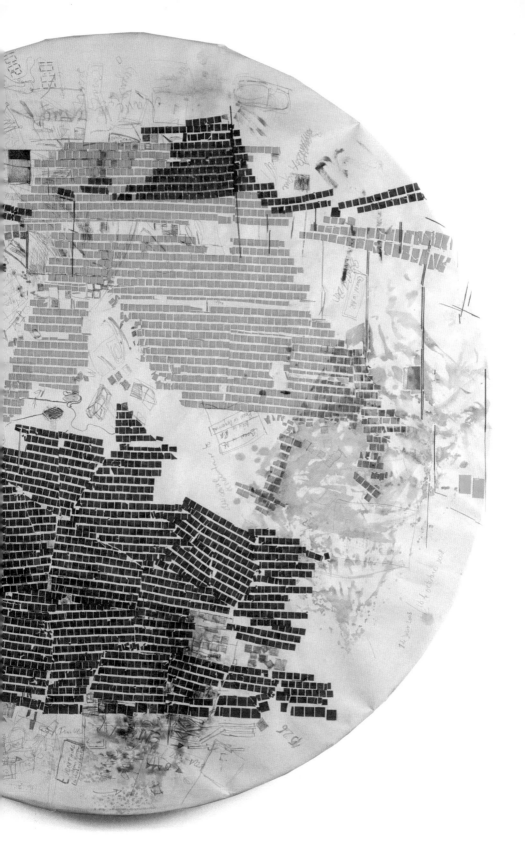

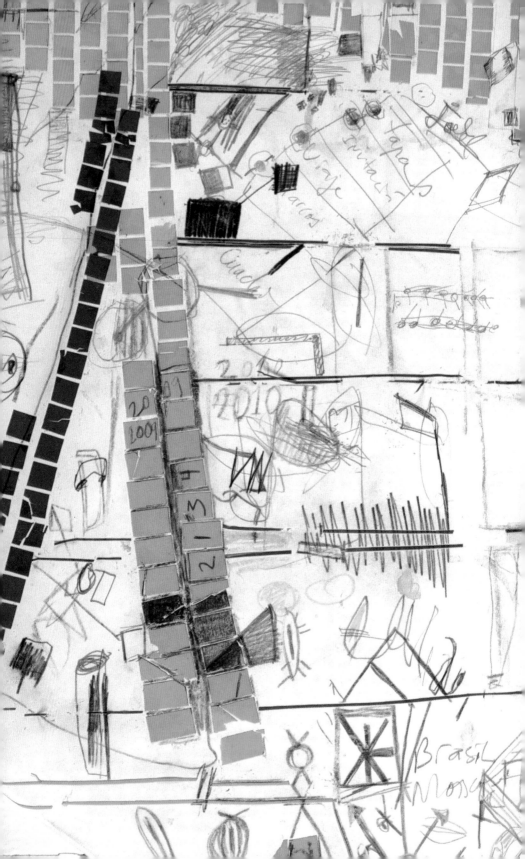

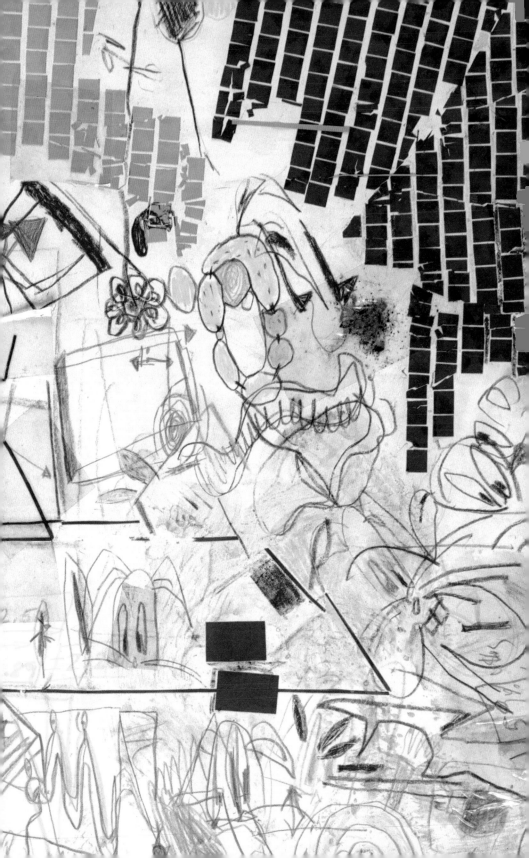

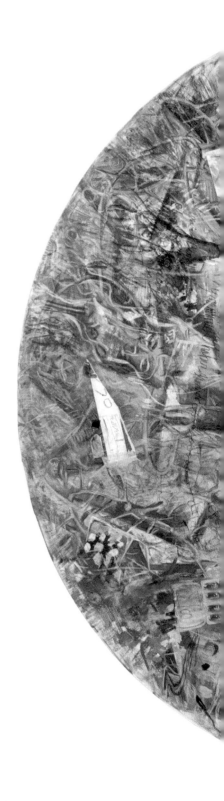

PL. 9
16 October 2008 – 14 April 2009

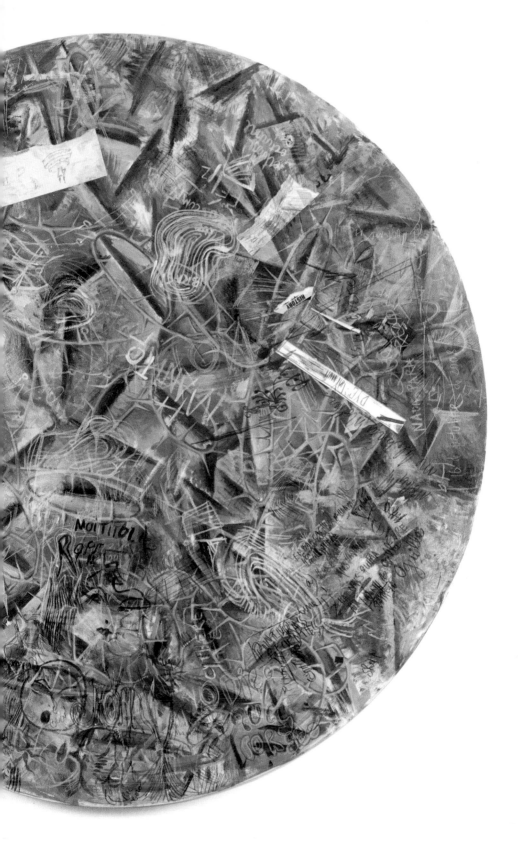

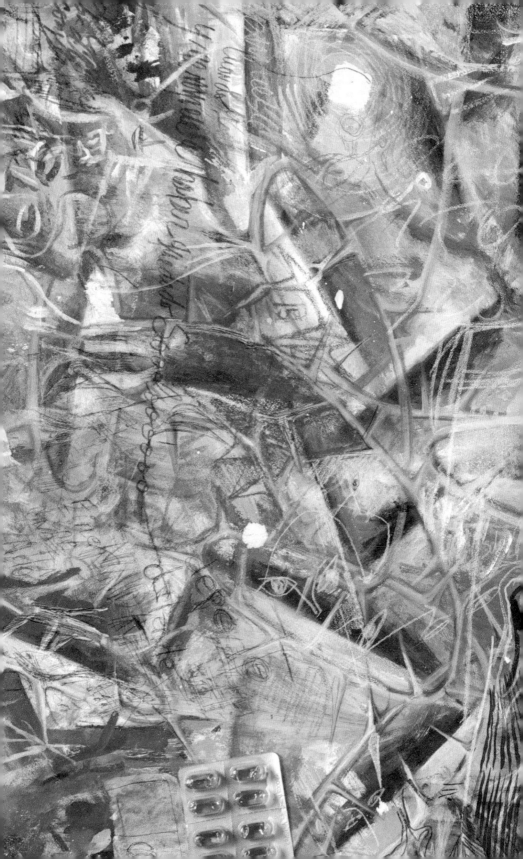

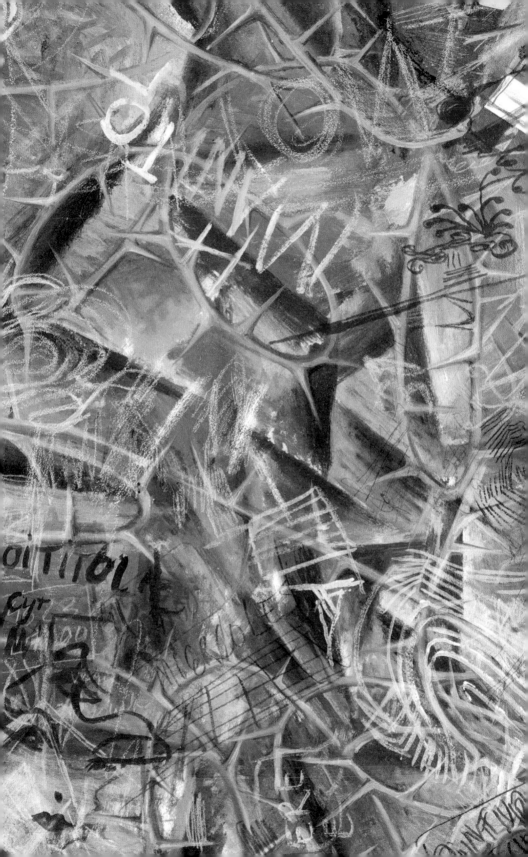

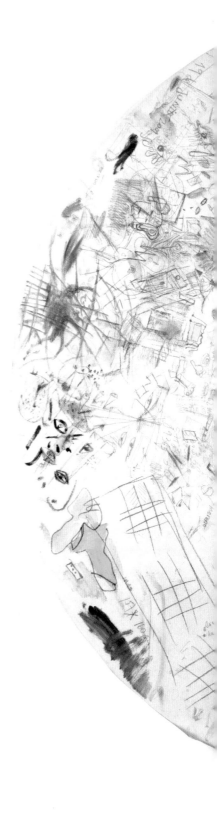

PL. 10
14 April – 19 June 2009

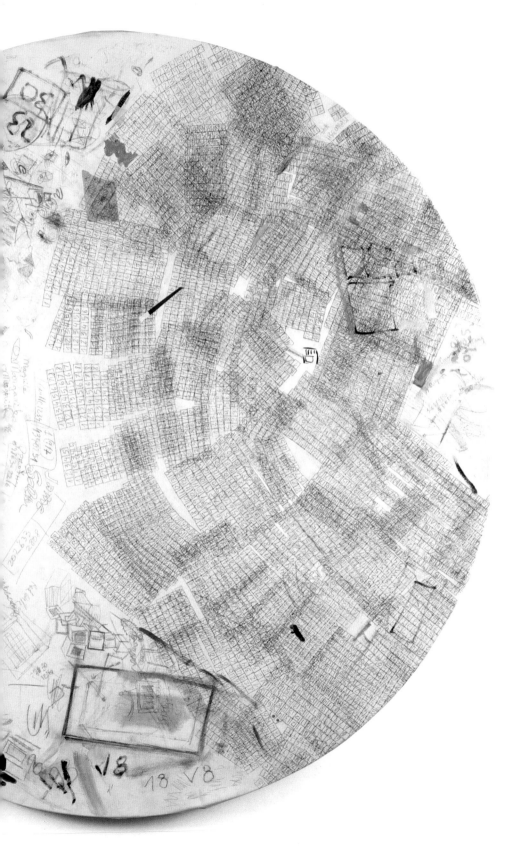

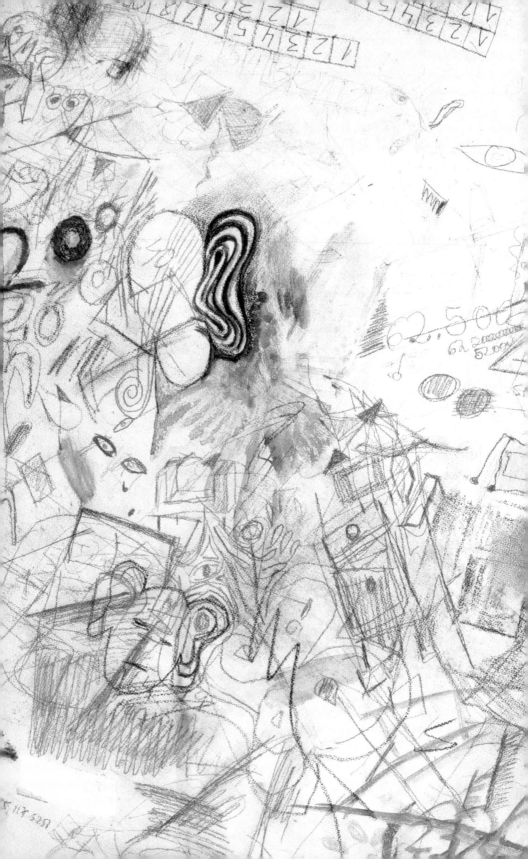

Guille 1234

1 (917)
434-0251

Jaime
Salter

Dorothy
9863-7216

rite
rgarite
Marganite

Hola
Hola
Hola

amable

1000 1500
1250 1650
1300

62.000
62.250
62.500
62.700
62.300
63000

Cupid

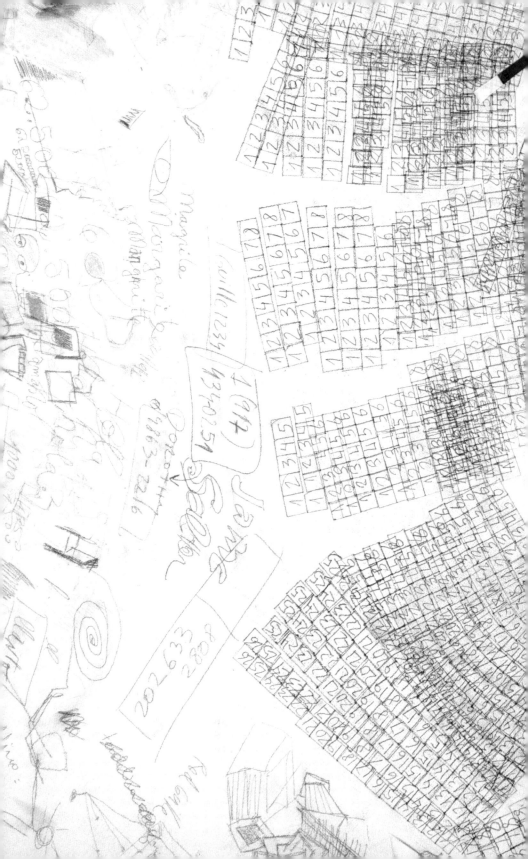

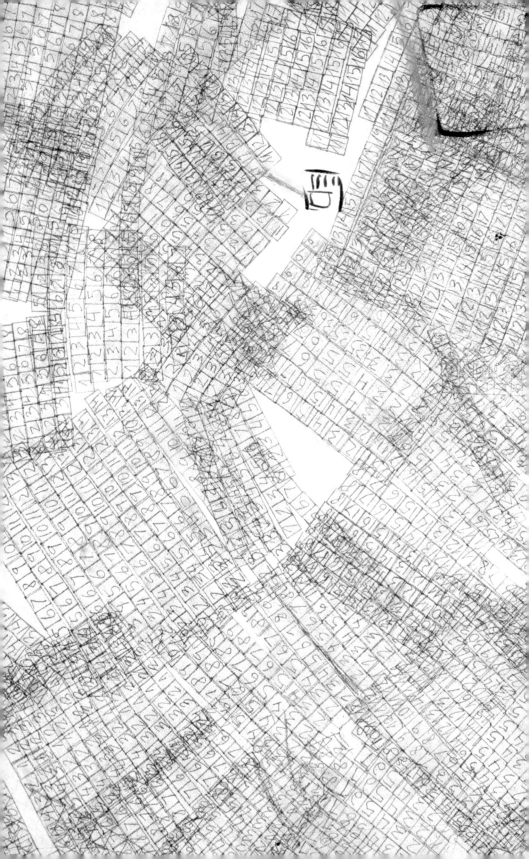

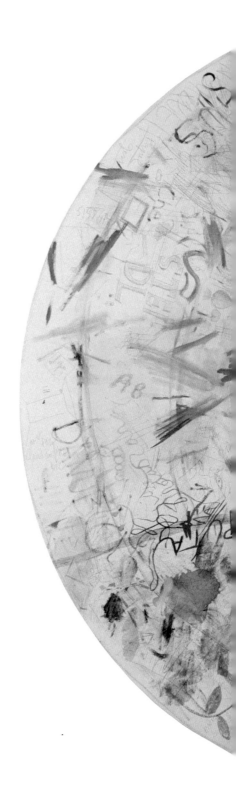

PL. 11
19 June – 6 November 2009

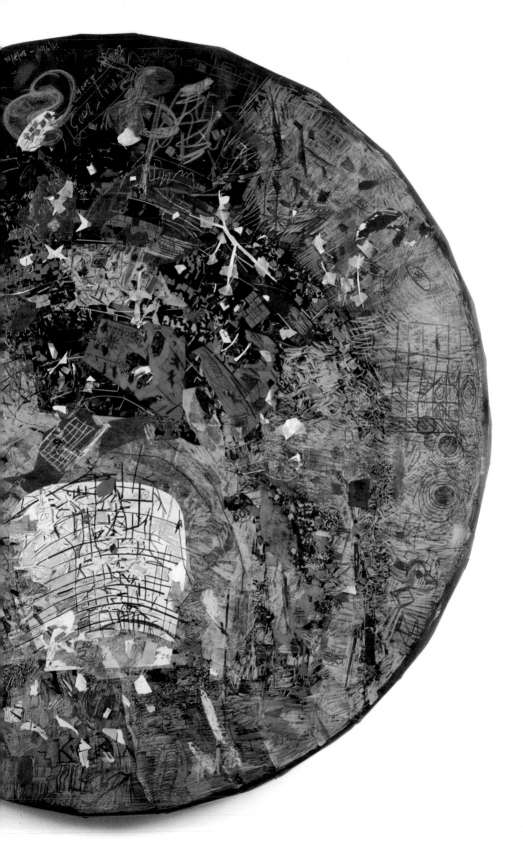

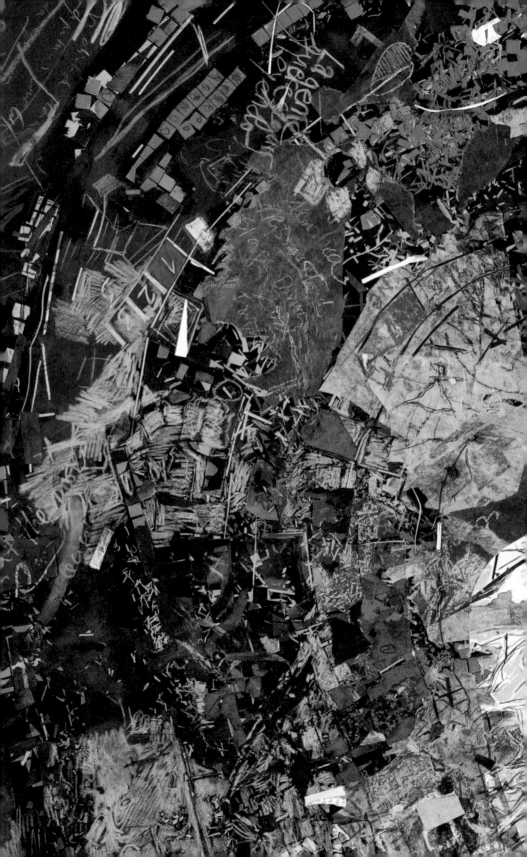

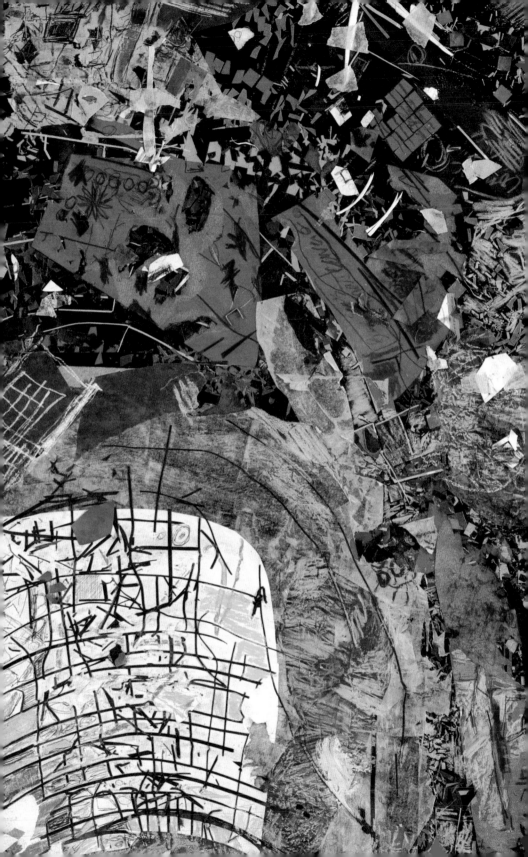

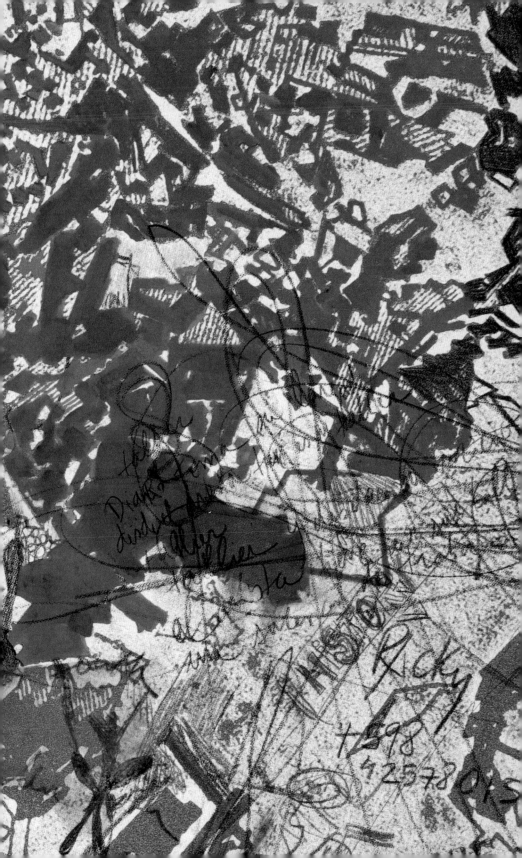

Of Cities, Maps, and Lines

Daniel Kehlmann

Kuitca's art is uncanny because it's so puzzling. One of his themes is confusion, the nooks and crannies of a labyrinth. It's no surprise that Kuitca is interested in maps of all kinds, but in his oeuvre, maps suddenly stop doing what they were actually invented to do: provide an overview. They no longer describe the terrain, but the confusion of someone who can't get his bearings in it. They don't help to orient me; they explain how it is that I can't get oriented.

Kuitca's *Diarios* are a special kind of map: panels, tabletops on which idea and form, accident and plan, everyday and artistic reality—in short, life and work—achieve a remarkable, ambiguous balance. There are intertwining patterns, there are complex shapes and designs, but there are also scribbles, telephone numbers, stains left by drinking glasses, and all the traces of the bustling everyday life surrounding the artist, while he—secretary, valet, and personal assistant in one—attends to the needs of the part of himself that really matters. Kuitca manages to capture in his art what is usually considered to be not yet a part of art. How much one would like to write the way he paints—if only one knew how!

Kuitca's art doesn't put distance between itself and me as I look at it. In the truest sense of the words, it comes to meet me halfway. It shows the conditions of its creation. It contains the quotidian, harbors within itself everything that classical aesthetics expects art to overcome in order to count as art. *Guillermo Kuitca: Everything*, the title of a book that collects Kuitca's work between 1980 and 2008, could not be more apt. Everything—not in a horizontal, encyclopedic, taxonomic sense however, but vertical, so that even the smallest detail contains all the layers of existence: the high and the low, the complex and the simple.

I'm writing these lines in New York City, in a sublet right on Washington Square. While I think about Kuitca, the world outside is roasting in the summer heat. The playgrounds are empty, the air conditioners drone fecklessly, heated air shimmers above the asphalt streets. It is terrible, but there's also something strangely beautiful about it all, and how much I would like to follow Kuitca's example and make notes on the tabletop. But that's easier said than done, because first of all, my notes would not end up being beautiful, and secondly, it's not my table. I get up, go to the window, and imagine myself down in the street, imagine walking along the south side of Washington Square, past the booksellers with their used paperbacks bleaching in the sun (a lot of William James, a lot of Hesse, the perennial Bhagavadgita, a bit of Kant, never any Hegel) and the food trucks radiating heat. I imagine that, although the sun is so strong it makes me dizzy, I'm thinking about a short story I've been meaning to write for a long time, about a painter who's decided to paint the heat—not its effect, not its color, but heat itself, its fiery, pitiless essence—but then I see a young man and a woman arguing on the other side of the street. It's often been said that every writer, every artist, is a kind of spy, an intrusive and indiscrete individual more interested in other people than he ought to be. The young man is wearing black-rimmed glasses. His face is long and narrow and he's close to tears. The woman is gesticulating energetically, waving her hands as if she wants to keep him at a distance. She is clearly the stronger of the two and a good fifteen years older. Neither looks as though they were intimate, but at the same time, they're obviously close enough to be able to insult and wound each other; I wish I could hear what they're saying. So I stop at a table and pick out a book at random. The bookseller is wearing a long-sleeved lumberjack shirt. It's a mystery to me why he's not sweating, and as I pay for my purchase, he gives me a disparaging look as if he can tell the book is just a ruse. I don't notice until I'm crossing the street that it's a book about art, a scholarly monograph on form and structure that would explain a lot to me, but its letters begin to swim before my eyes because I'm concentrating so hard on the arguing couple next to me.

Unfortunately, however, it doesn't work. They're speaking a language I don't understand, a language so foreign I don't even know

what language it is. While I listen, while the young man sounds more and more despairing and the woman more and more cutting and dismissive, I realize that I will never know what the argument is about, and that I understand so little that I'll never be able to make anything out of it. There will be no story. From the corner of my eye, I see the man take off his glasses and put his fingers to his eyes. Perhaps he's crying, but maybe that's a hasty conclusion; I can't tell. The woman turns away and makes what sounds like a quiet laugh. Suddenly, I realize she's looking at me. I look up from my book and our eyes meet. Something about the way hers are slanted, something about the intensity of her stare, makes me afraid. I quickly close the book and move on—or more accurately: I would move on if it didn't occur to me at this very moment that I'm still standing here at the window, next to the humming air conditioner, and looking down at the street, where—although I can just barely still see the two arguing—it's impossible to know what language they're speaking, to say nothing of exchanging glances with one of them. And while I'm still surprised at this confusion about my own location, I realize I've long since left the window and am sitting at the computer that's on the table whose top I have, of course, not scribbled on while imagining standing up and going to the window. The phone next to me vibrates. On the display I see a number I don't know. Of course, I don't pick up.

Kuitca's work resists clear classification. Is he a graphic artist, a sculptor, or a painter? Is he representational or abstract? Does he copy or invent anew? Is it about the world or about him? His unique quality consists in the fact that such questions make no sense, and the best appreciation is perhaps not analysis, but admiring imitation. For those familiar with Kuitca, every image becomes a map and every map becomes a work. Those familiar with Kuitca's work are sometimes overtaken on the street by a feeling of unreality, a sense that they are no longer moving along a well-ordered system of city streets, but through a tangled image. That happened to me recently in my home town of Vienna, thinking back on that moment in New York. While I wondered whether Kuitca would agree with me if I declared him to be a relative of the cartographer in the classic and surely too-often quoted—though still worth quoting—story by Jorge Luis Borges (the cartographer

who designs a map of the empire that is as large as the empire it represents, corresponding to it point for point), whose final, metaphysically witty sentence, runs, "In the Deserts of the West, still today, there are tattered Ruins of that map, inhabited by animals and beggars; in all the land there is no other relic of the disciplines of Geography"—while I think about that story, only a single paragraph long, and wish I had written it or that I could ever write anything as good, and while I think about the question of whether Kuitca often thinks of that story by his compatriot Borges while he works, I cross the Graben and walk down the Naglergasse, a narrow, crooked street along which, almost two millennia ago, ran the defensive wall of the ancient Roman camp of Vindobona that gave Vienna its name, and where the emperor Marcus Aurelius wrote one of the wisest books of all time about moderation, gentle prudence, and the acceptance of death. Today, there are dozens of scaffolded buildings here. It's a lot of work to maintain such an old city. A layer of glaring metal obstructs the view of the old stucco facades; the strange interplay of both could just as well have been designed by Kuitca, as could the peculiar geography of the center of Vienna. Just when you least expect it, the street opens up and you find yourself standing on the broad Freyung Square, ringed by pompous edifices built to administer an empire that has long since ceased to exist. The weather is cool, pigeons flutter up, two horse-drawn carriages, relics of a past that was never that idyllic, roll languidly over the cobblestones. Unlike New York or Buenos Aires, Vienna is not a city of storytellers. It is the city of analysts and flaneurs, the city of Musil, Freud, and—of course—Wittgenstein, the place where they invented the abstract branch of modernism—not surrealism, but the confidence in diagrams and lucid forms. And yet, the city is not all that orderly. It has its nooks and crannies and paradoxes and resembles the scribbles on Guillermo Kuitca's tabletop much more than the clear concepts of *Neue Sachlichkeit*.

As I climb the stairs to my apartment, I suddenly think once more of distant New York. I think of the story I didn't write, the man and woman arguing in the heat whom I have never forgotten, strange to say, although I'll never write about them, and I think of Kuitca's faraway studio, in another hemisphere, almost in another world. I think about his tabletop, at once a work of art and an object of every-

day use, and about the picture on it and its origin in happenstance as much as in plan and intention. Every work of art is the result of a continuous negotiation between those poles, but very seldom does art reveal this inner conflict to us in such complexity. So I think about his tabletop and I'm happy, and wish I were there to see everything up close: the tangle of lines and colors, clear as a map, beautiful as a painting, and as mysterious as a language I will never understand.

Translated by David Dollenmayer

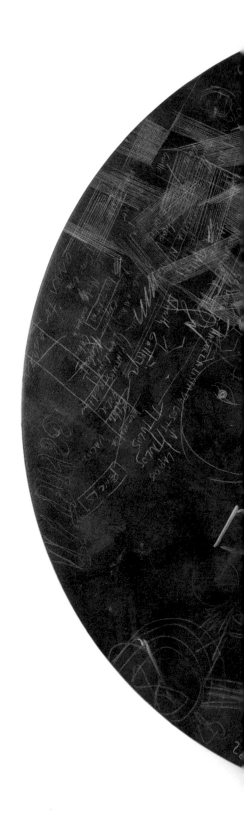

PL. 3
14 March – 20 July 2006

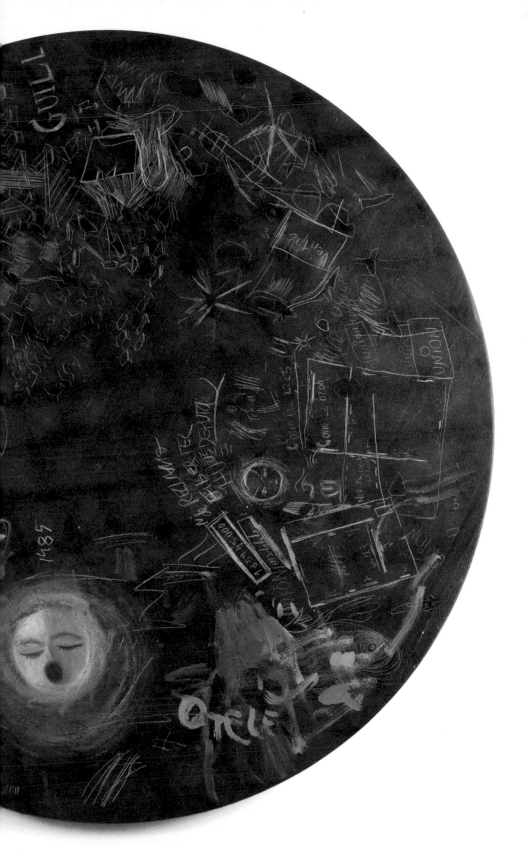

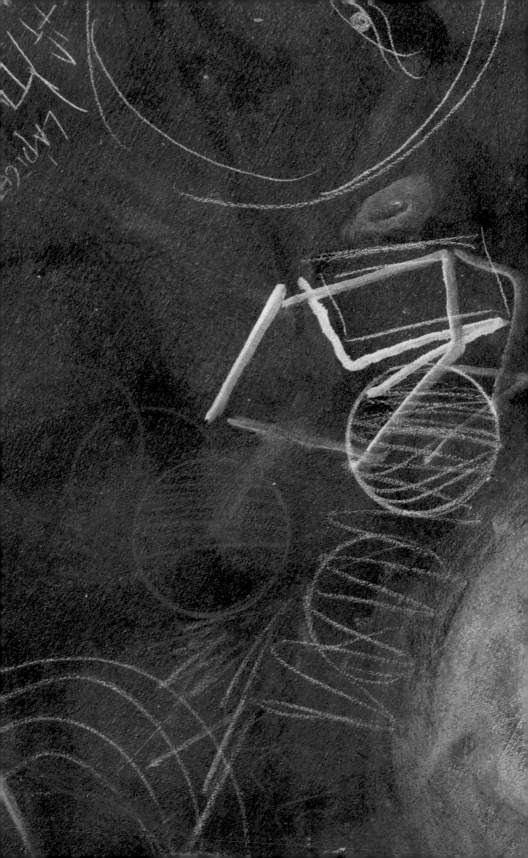

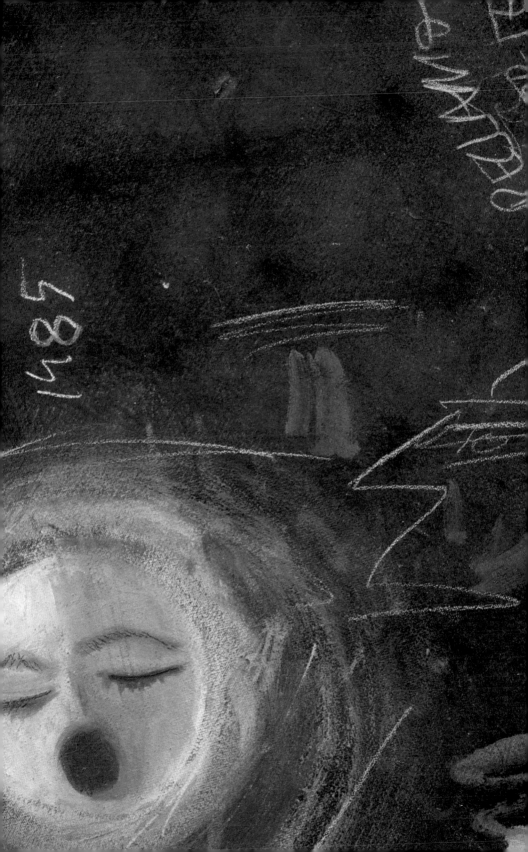

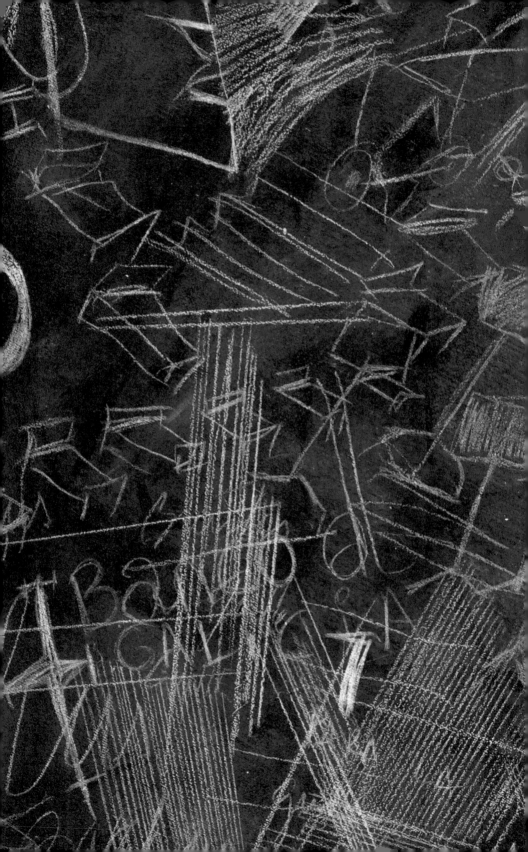

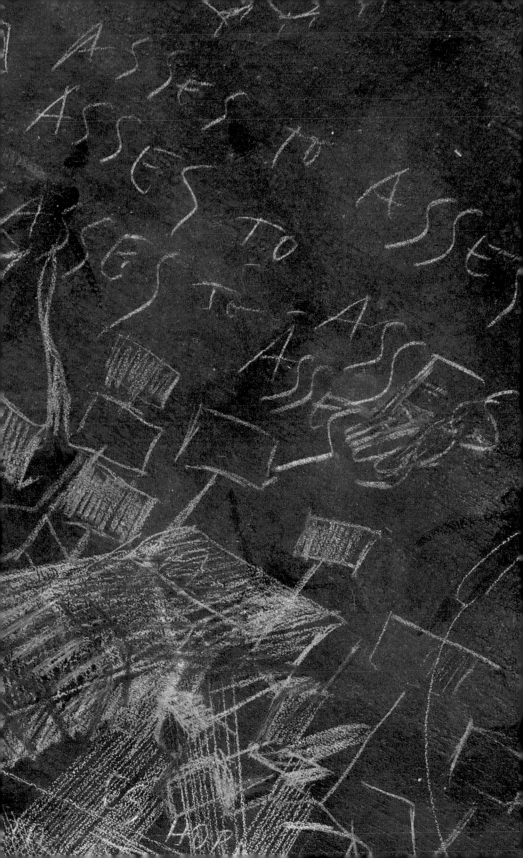

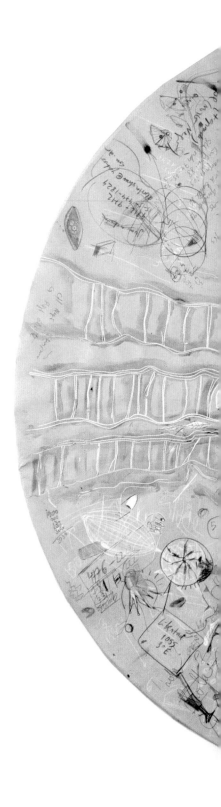

PL. 4
20 July – 12 December 2006

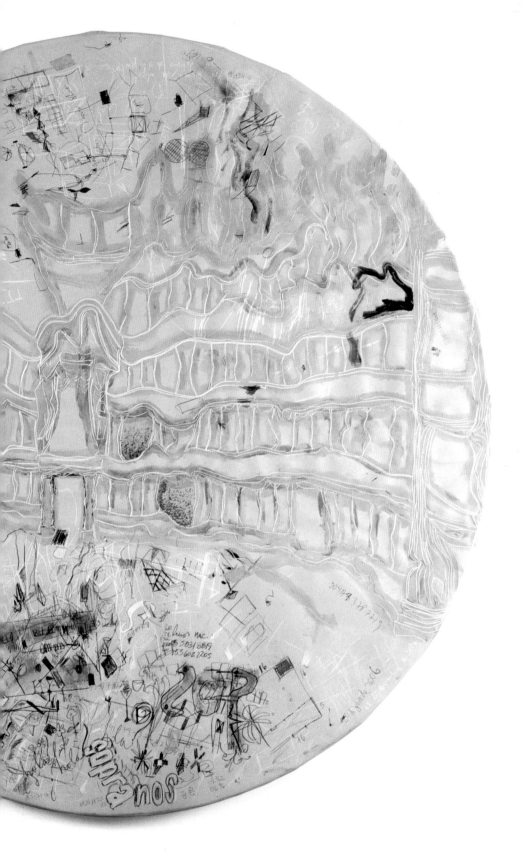

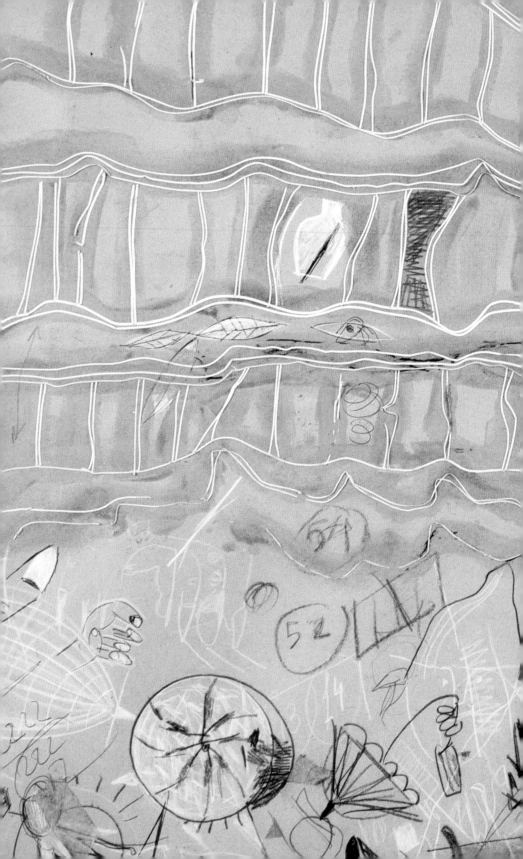

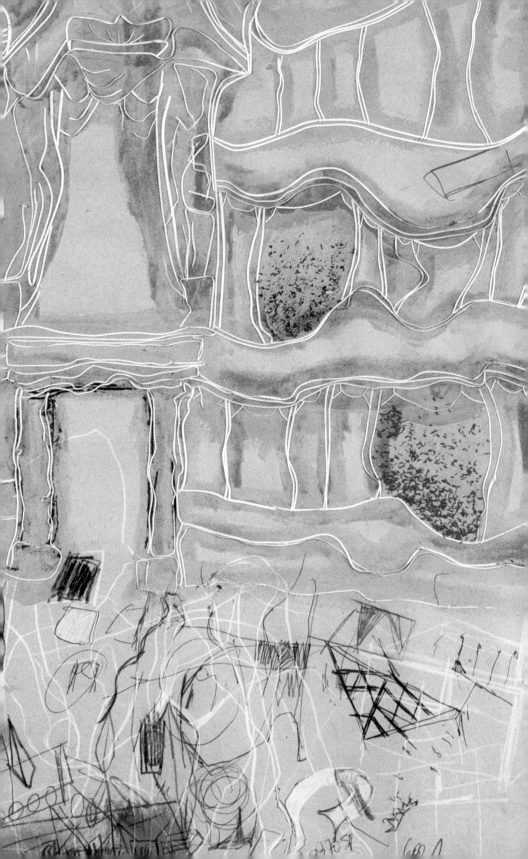

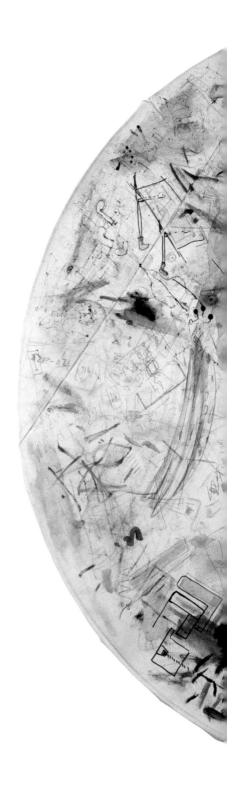

PL. 5
14 December 2006 – 17 August 2007

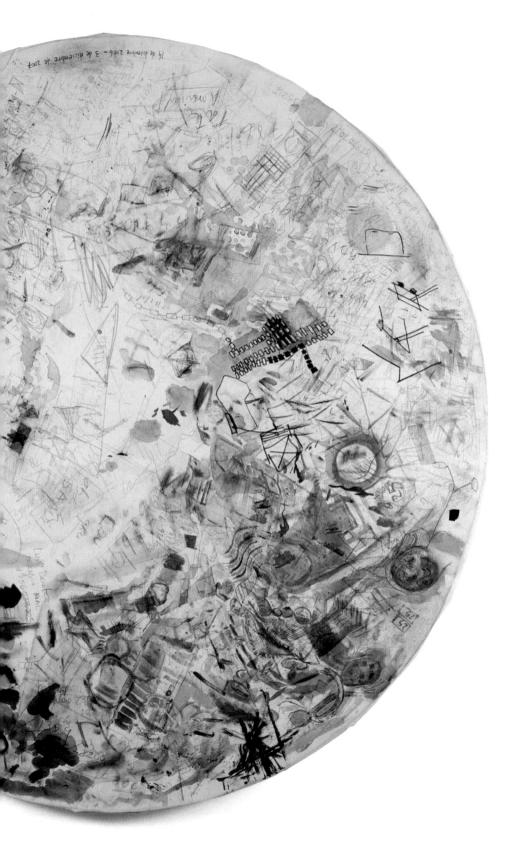

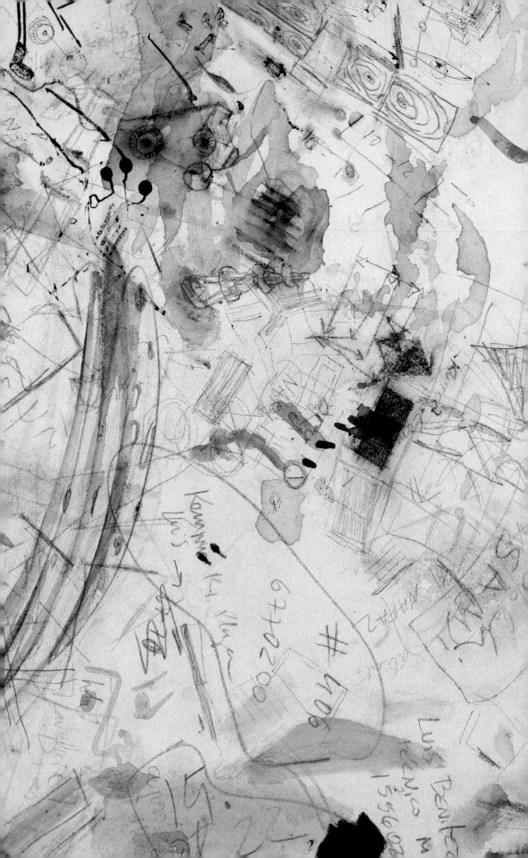

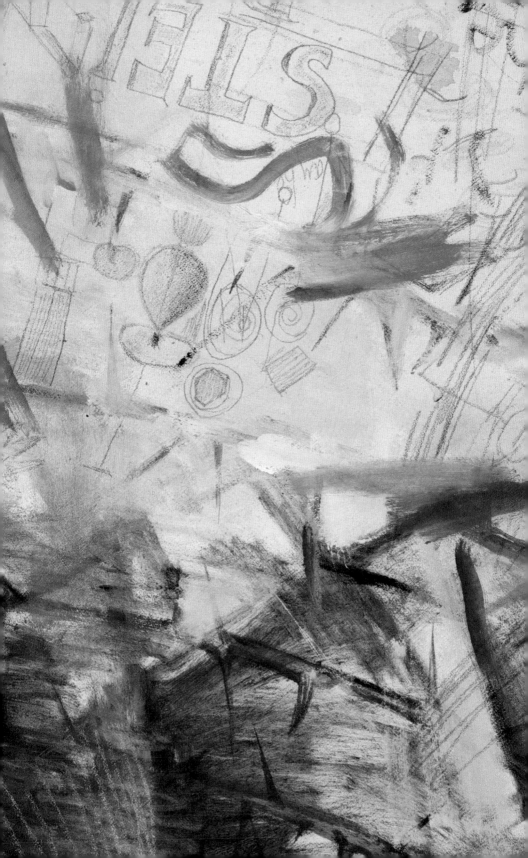

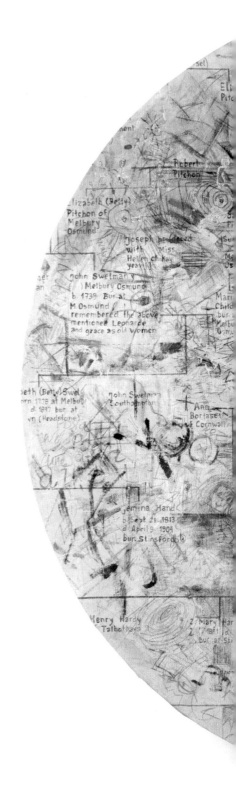

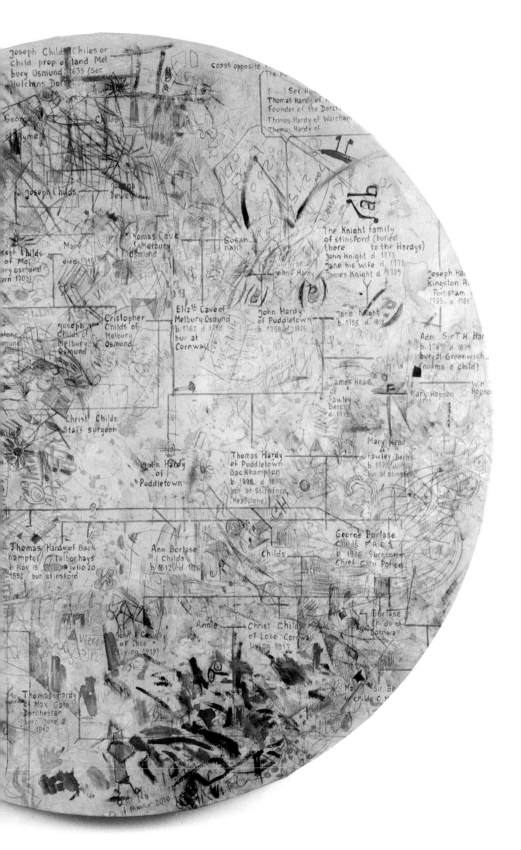

h (Betty)
of
y

Joseph produced
with ... Miss
Hellen or Kay
yeavily

Swetman y
elbury Osmund
g Bur at
und (...)
nbered the above
oned Leonarde
ace as old women

Bartjew
Pitchok
of
Summer

Melbury
Osmund

Maria
Childs
bur. at
Melbury
Osmund

Jose
c
bur
(bor

Eliz th
Headst
of Osm

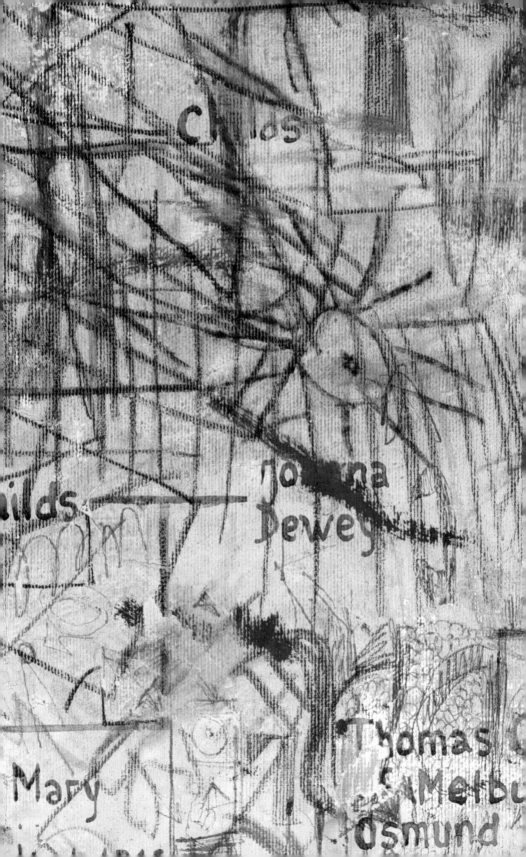

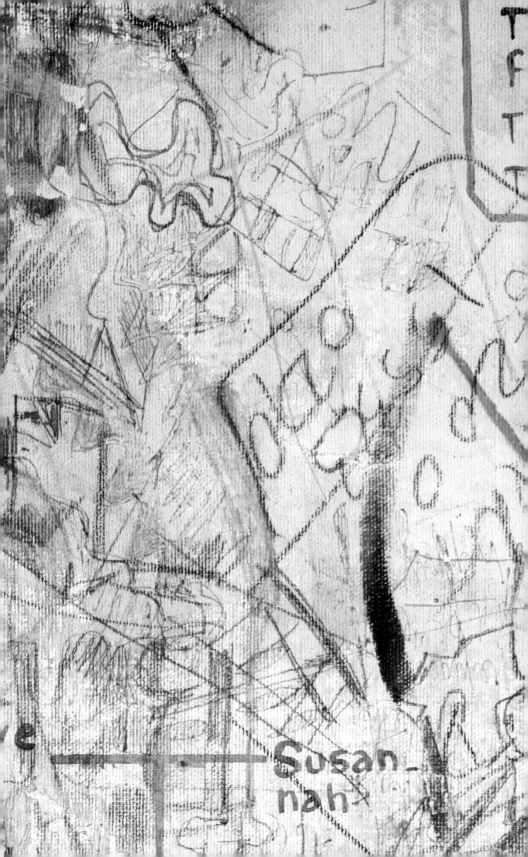

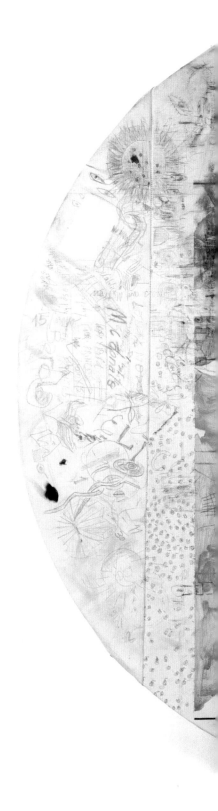

PL. 13
17 March – 6 July 2010

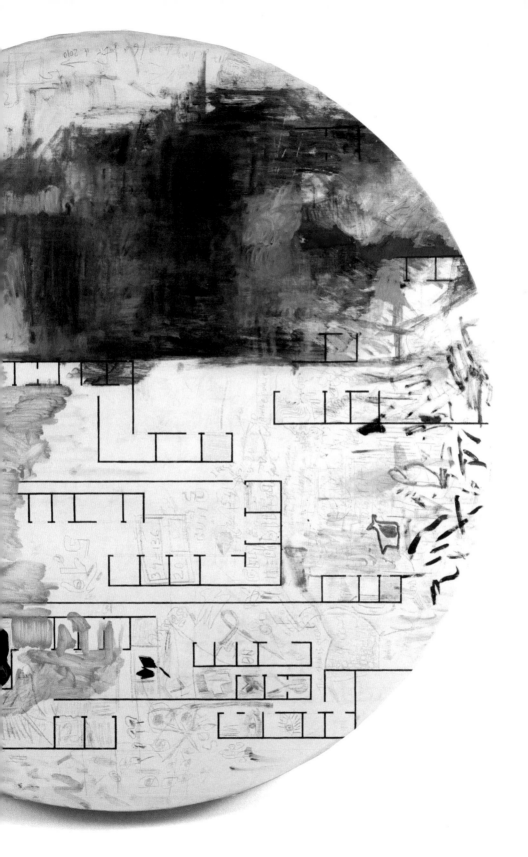

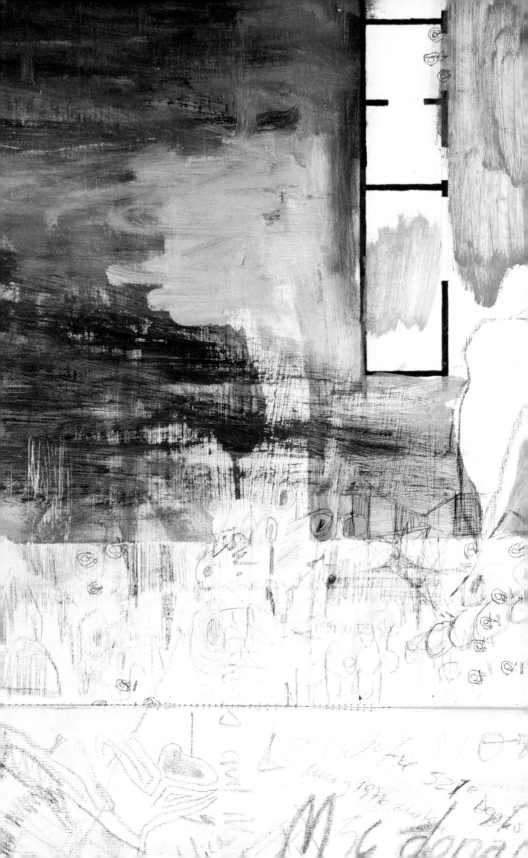

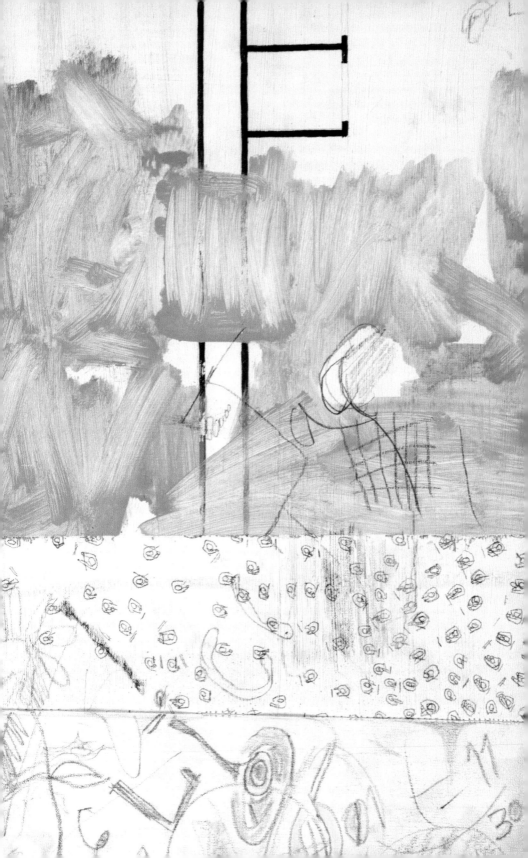

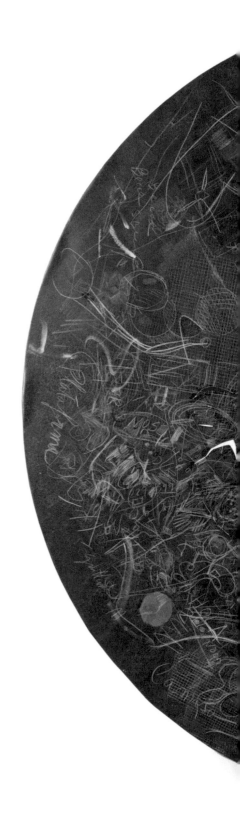

PL. 14
6 July – 25 November 2010

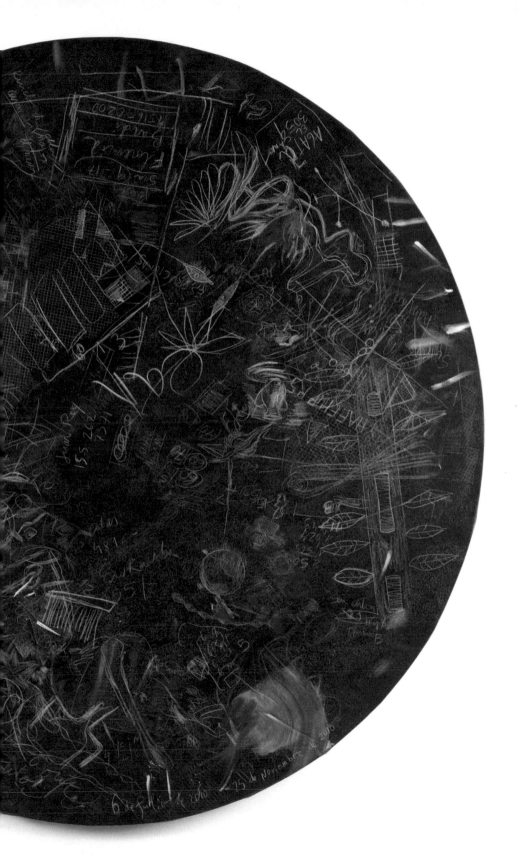

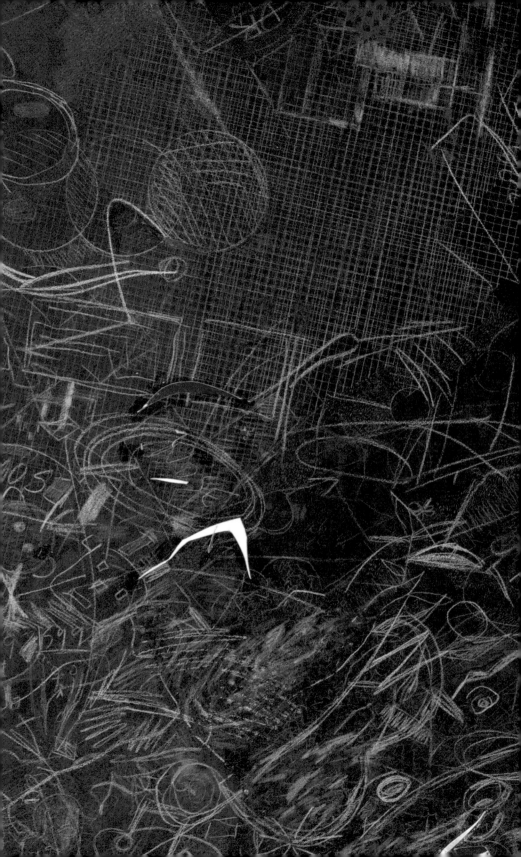

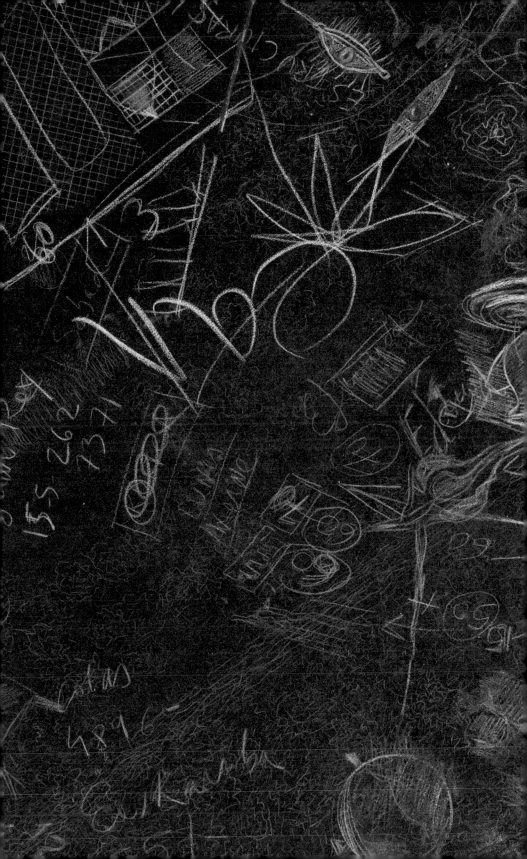

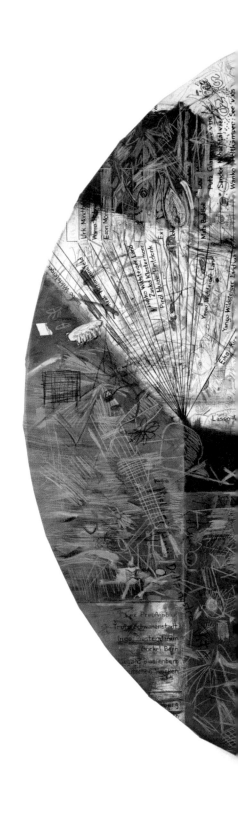

PL. 15
25 November 2010 – 12 April 2011

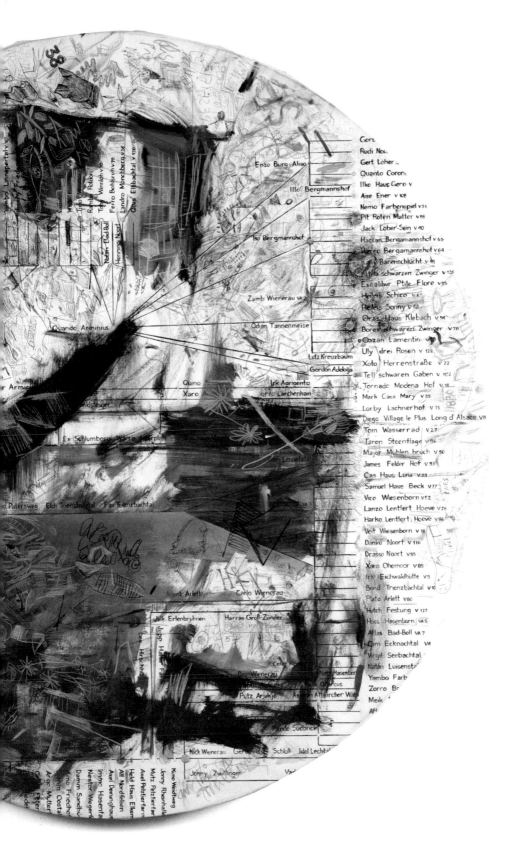

Quando Arminius

LUREX

Xaver Armin

Wildsteiger

Ex Schlumborn Worro Asterplat

Grando Patersweg Elch Trienzbachtal Fax Trienzbachtal

Jalk E

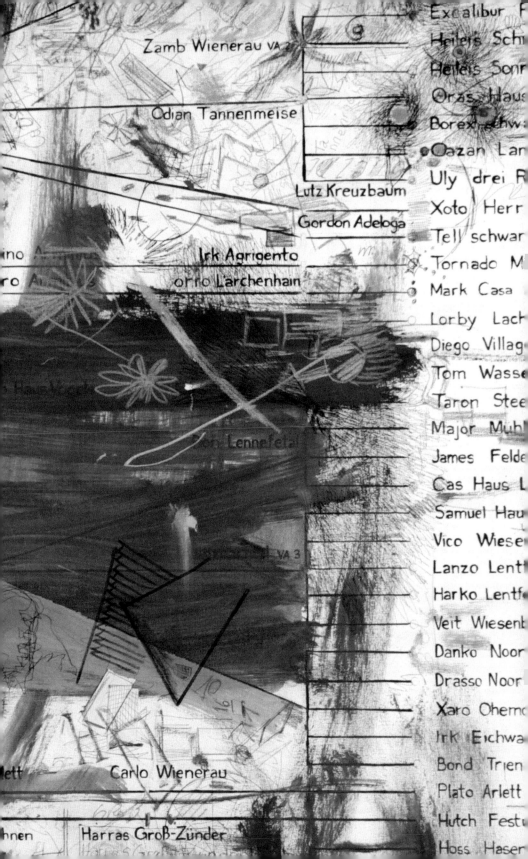

Zamb Wienerau VA

Odian Tannenmeise

Lutz Kreuzbaum

Gordon Adeloga

Irk Agrigento

orro Lärchenhain

on Lennefetal

VA 3

Carlo Wienerau

ett

hnen Harras Groß-Zünder

Excalibur

Heiters Schi

Heiters Sonr

Oras Haus

Borex chw

Oazan Lan

Uly drei R

Xoto Herr

Tell schwar

Tornado M

Mark Casa

Lorby Lach

Diego Villag

Tom Wasse

Taron Stee

Major Mühl

James Felde

Cas Haus L

Samuel Hau

Vico Wiese

Lanzo Lentf

Harko Lentf

Veit Wiesenb

Danko Noor

Drasso Noor

Xaro Ohemo

Irk Eichwa

Bond Trien

Plato Arlett

Hutch Festu

Hoss Haser

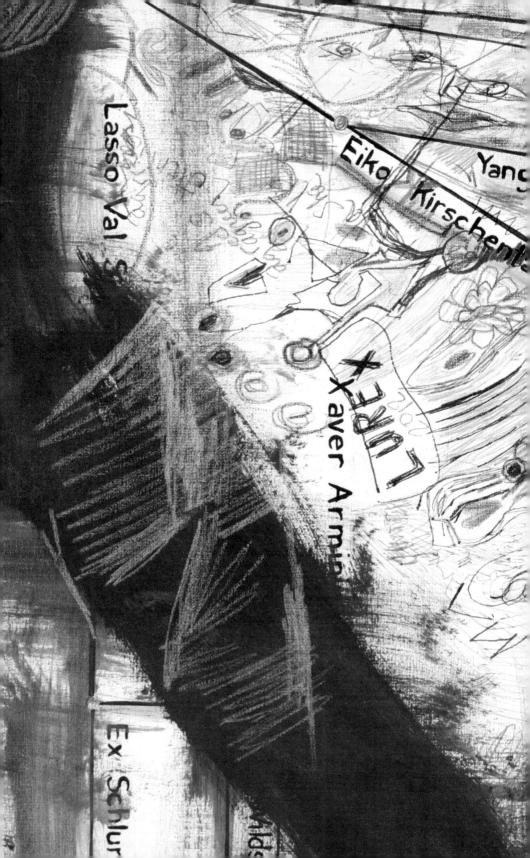

Widsteiger Land

Hästeiger Land VAS

Mats Bad-Boll

Vax Arjakjo

Lou

Püt

Sar

Wa

Wut

Irk=

Drac

Uran

Qua

Yan

Ban

Cim

Wid

Tind

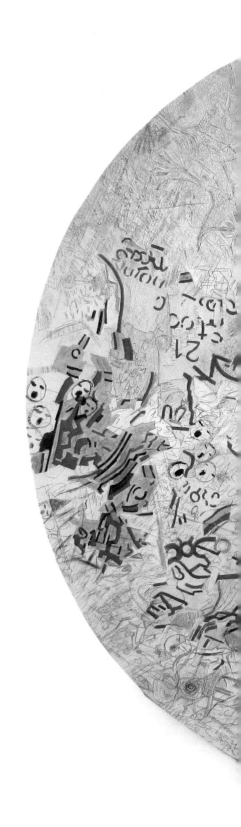

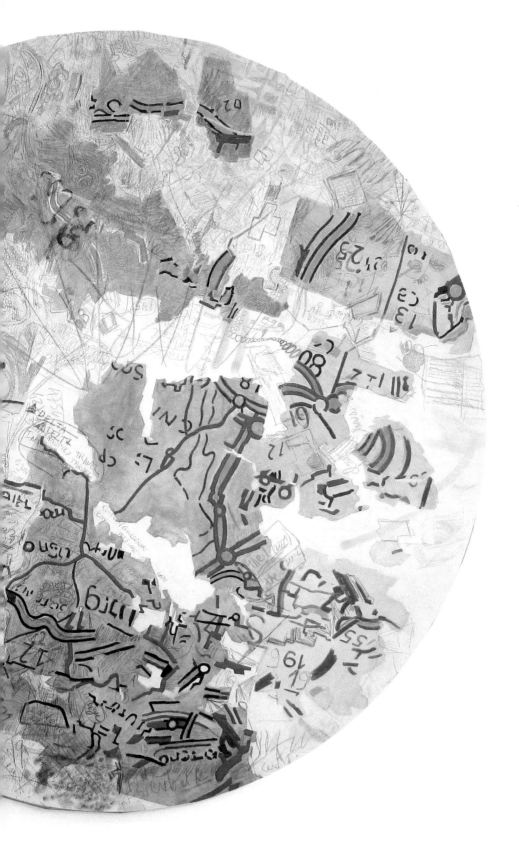

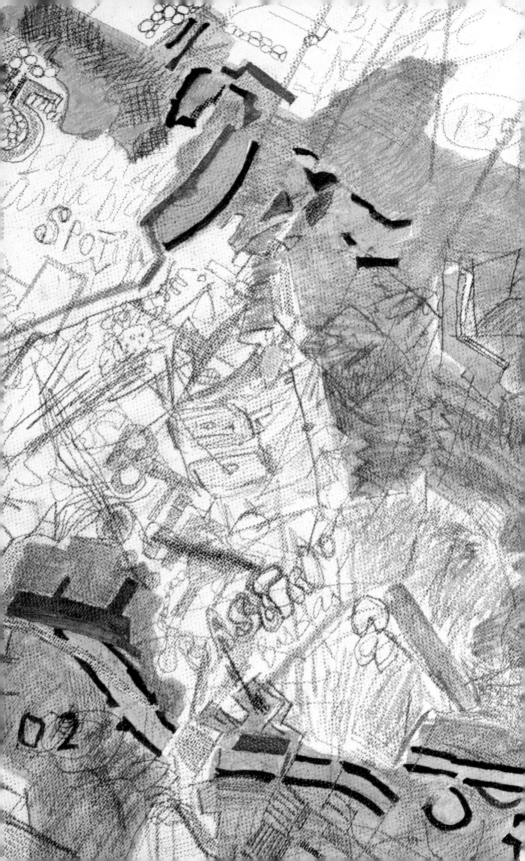

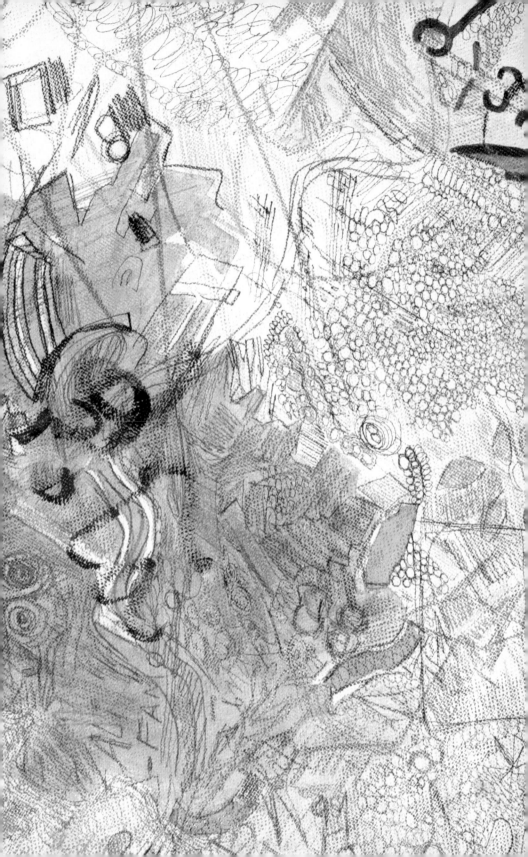

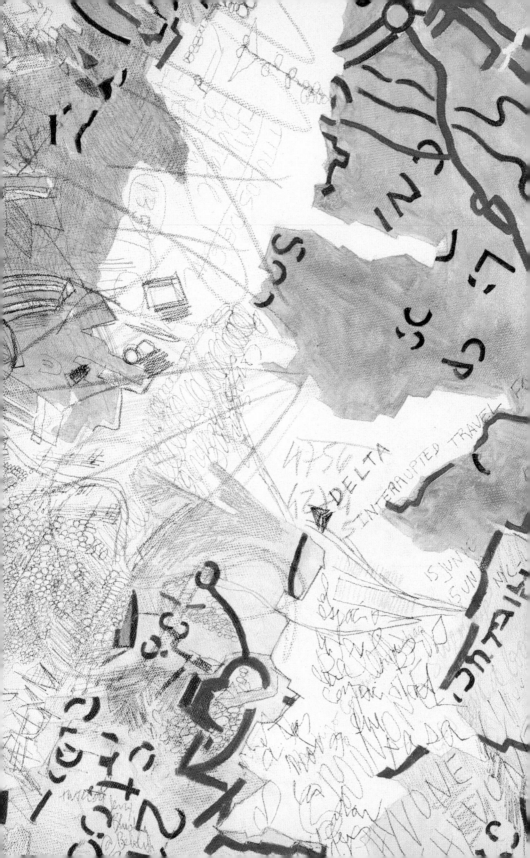

DELTA

INTERRUPTED TRAVEL

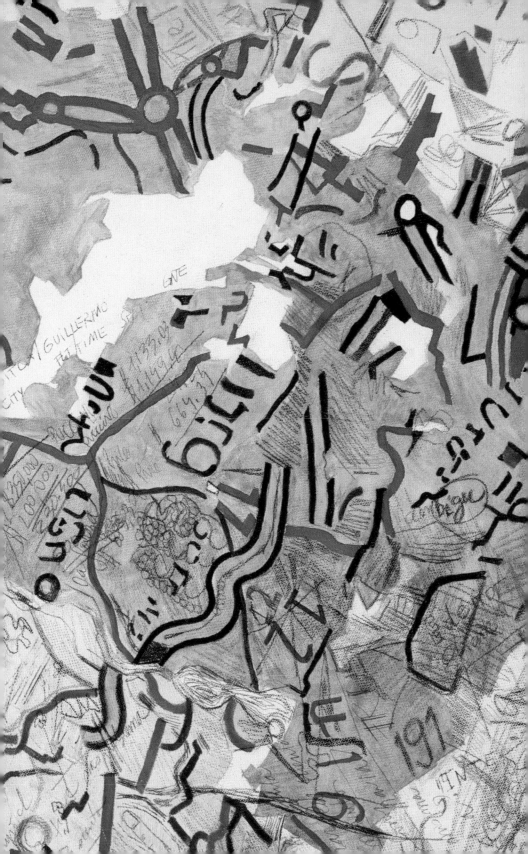

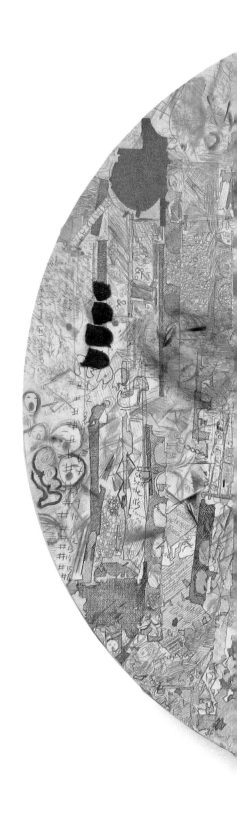

PL. 17
30 September 2011 – 10 March 2012

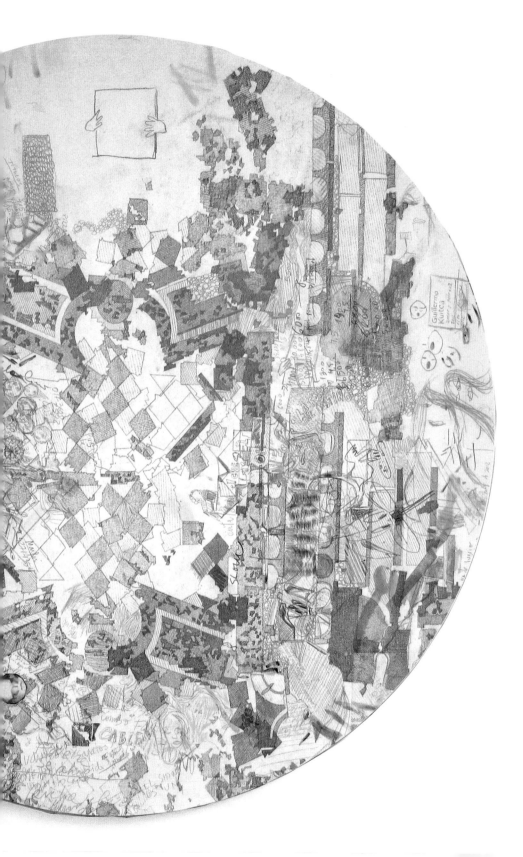

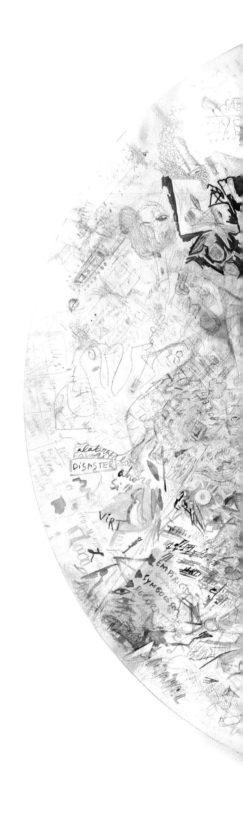

PL. 18
10 March – 3 September 2012

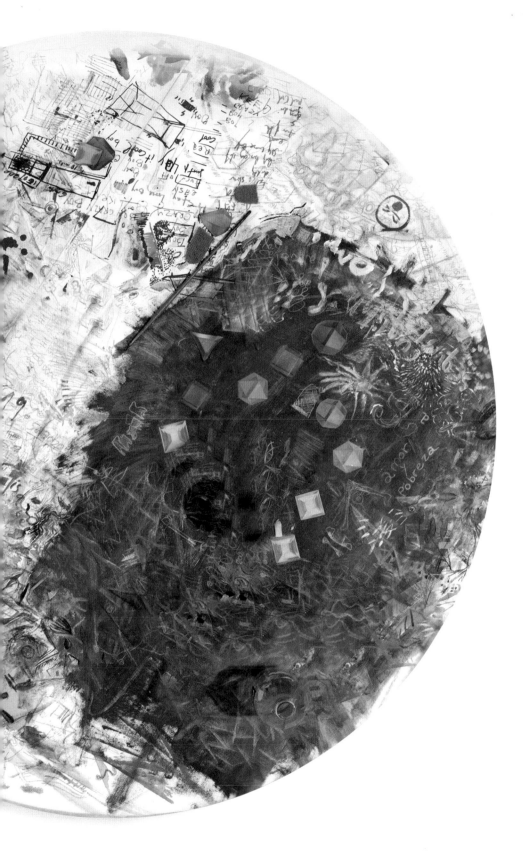

LIST OF WORKS

PL. 1
25 May – 20 October 2005
2005
Mixed media on paper

PL. 2
20 October 2005 – 14 March 2006
2006
Mixed media on canvas

PL. 3
14 March – 20 July 2006
2006
Mixed media on canvas

PL. 4
20 July – 12 December 2006
2006
Mixed media on paper

PL. 5
14 December 2006 – 17 August 2007
2007
Mixed media on canvas

PL. 6
17 August – 3 December 2007
2007
Mixed media on canvas

PL. 7
3 December 2007 – 1 July 2008
2008
Mixed media on canvas

PL. 8
1 July – 16 October 2008
2008
Mixed media on paper

PL. 9
16 October 2008 – 14 April 2009
2009
Mixed media on canvas

PL. 10
14 April – 19 June 2009
2009
Mixed media on canvas

PL. 11
19 June – 6 November 2009
2009
Mixed media on canvas

PL. 12
6 November 2009 – 17 March 2010
2010
Mixed media on canvas

PL. 13
17 March – 6 July 2010
2010
Mixed media on canvas

PL. 14
6 July – 25 November 2010
2010
Mixed media on canvas

PL. 15
25 November 2010 – 12 April 2011
2011
Mixed media on canvas

PL. 16
12 April – 30 September 2011
2011
Mixed media on canvas

PL. 17
30 September 2011 – 10 March 2012
2012
Mixed media on canvas

PL. 18
10 March – 3 September 2012
2012
Mixed media on canvas

All works
47 1/4 inches diameter x 1 5/8 inches deep
(120 x 4.1 cm)
Collection of the artist
Courtesy Sperone Westwater, New York
Photographs by Jorge Miño

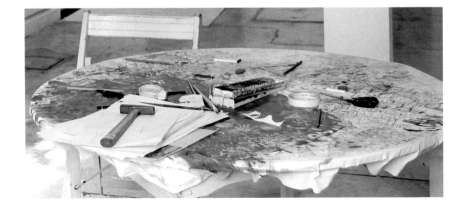

Brett Littman is Executive Director of The Drawing Center.

Daniel Kehlmann's *Measuring the World* was translated into more than forty languages. Awards his work has received include the Candide Prize, the Literature Prize of the Konrad Adenauer Foundation, the Heimito von Doderer Literature Award, the Kleist Prize, the WELT Literature Prize, and the Thomas Mann Prize. Kehlmann divides his time between Vienna and Berlin.

David Dollenmayer is a literary translator and emeritus professor of German at the Worcester Polytechnic Institute in Worcester, Massachusetts. He has translated works by Bertolt Brecht, Elias Canetti, Peter Stephan Jungk, Michael Kleeberg, Michael Köhlmeier, Perikles Monioudis, Anna Mitgutsch, Mietek Pemper, Moses Rosenkranz, and Hansjörg Schertenleib, and is currently at work on a translation of Martin Walser's *A Gushing Fountain*. He is the recipient of the 2008 Helen and Kurt Wolff Translator's Prize and the 2010 Translation Prize of the Austrian Cultural Forum in New York.

ACKNOWLEDGMENTS

Guillermo Kuitca: Diarios and its accompanying publication are made possible in part by Bettina and Donald Bryant, Jr., Charles Van Campenhout and Risteard Keating, Solita and Steven Mishaan, Cindy and Howard Rachofsky, and an anonymous donor.

The Mario Gradowczyk Public Program Series supports programming related to the institution's Latin American exhibitions and is funded by Felisa Gradowczyk, Diego Gradowczyk and Isabella Hutchinson.

EDWARD HALLAM TUCK PUBLICATION PROGRAM

This is number 100 of the *Drawing Papers*, a series of publications documenting The Drawing Center's exhibitions and public programs and providing a forum for the study of drawing.

Jonathan T.D. Neil *Executive Editor*
Joanna Ahlberg *Managing Editor*
Designed by Peter J. Ahlberg / AHL&CO

This book is set in Adobe Garamond Pro and Berthold Akzidenz Grotesk. It was printed by Shapco in Minneapolis, Minnesota.

LIBRARY OF CONGRESS CONTROL NUMBER: 2012951271
ISBN 978-0-942324-69-3

THE DRAWING PAPERS SERIES ALSO INCLUDES

THE
DRAWING
CENTER

35 WOOSTER STREET | NEW YORK, NY 10013
T 212 219 2166 | F 888 380 3362 | DRAWINGCENTER.ORG